		1
		\$
· ·		
	* _X	

42535725R00067

Made in the USA Columbia, SC 17 December 2018